Big Beautiful Bitch

**Black Paper Edition
An Uplifting Swear Word**

THIAGO ULTRA

Big, Beautiful, Bitch - Black Paper Edition - An Uplifting Swear Word Coloring Book

Copyright 2016 by Thiago Ultra

ISBN-13: 978-1535284448
ISBN-10: 1535284447

First edition, 2016

Artwork by Thiago Ultra

More about Thiago's books:
www.thiagoultra.com
www.facebook.com/tultra

Pick your shit up and start rocking the fuck out today!

The fun begins on the next page…

This book belongs to

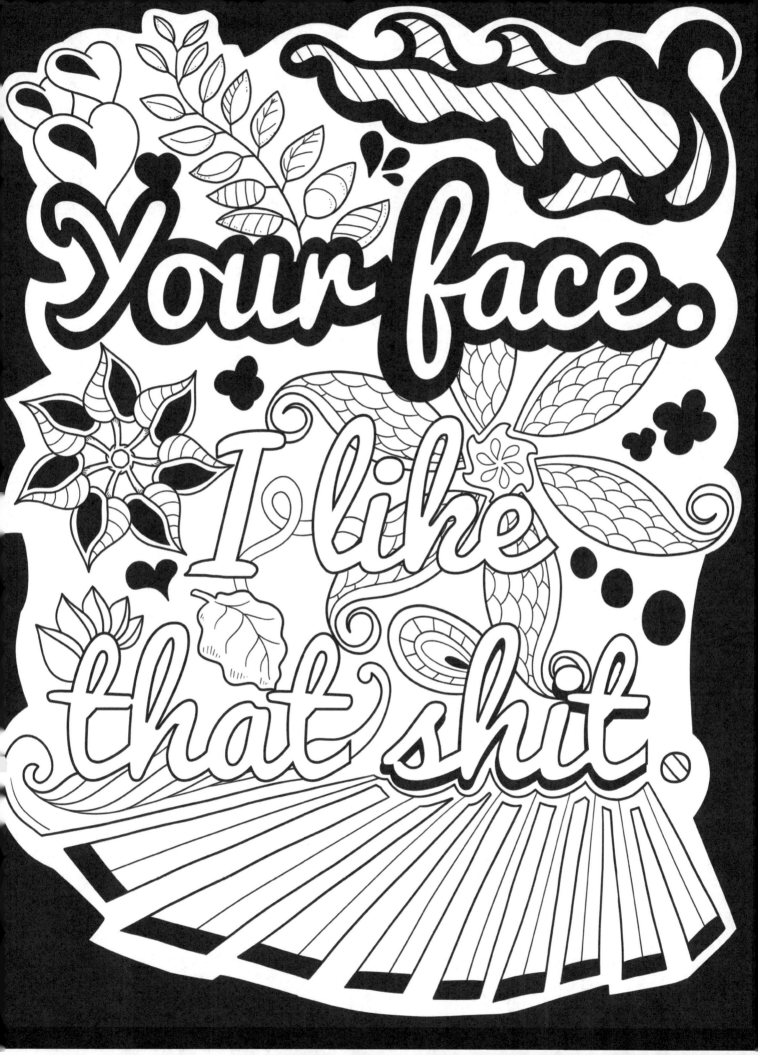

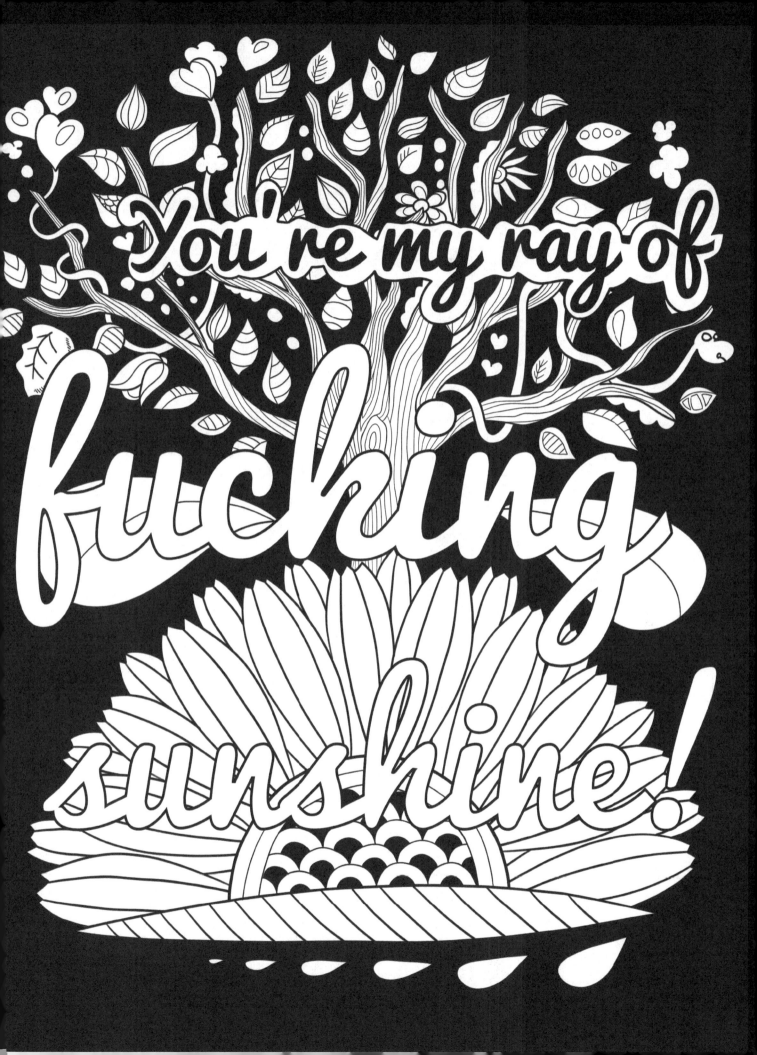

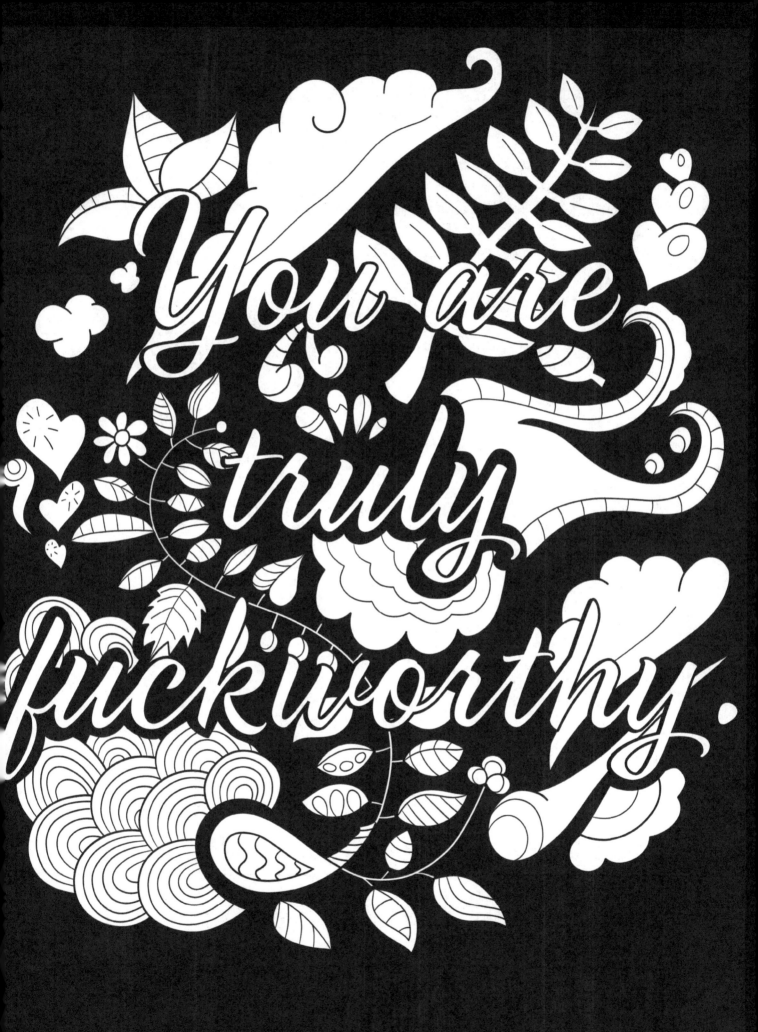

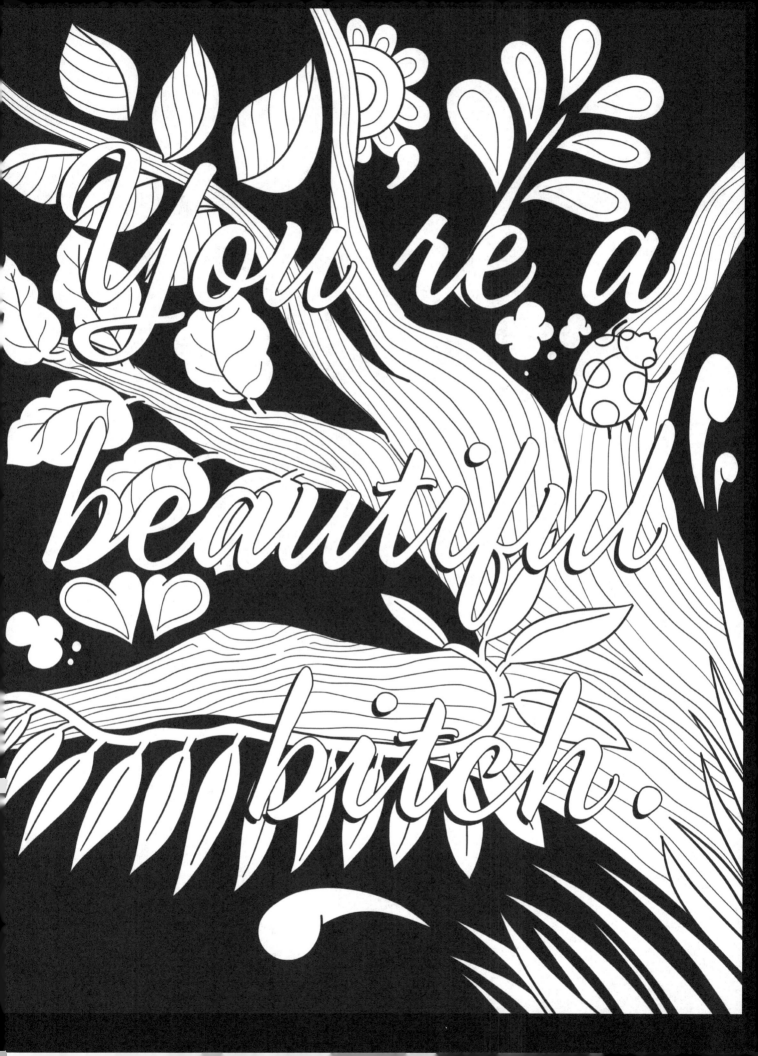

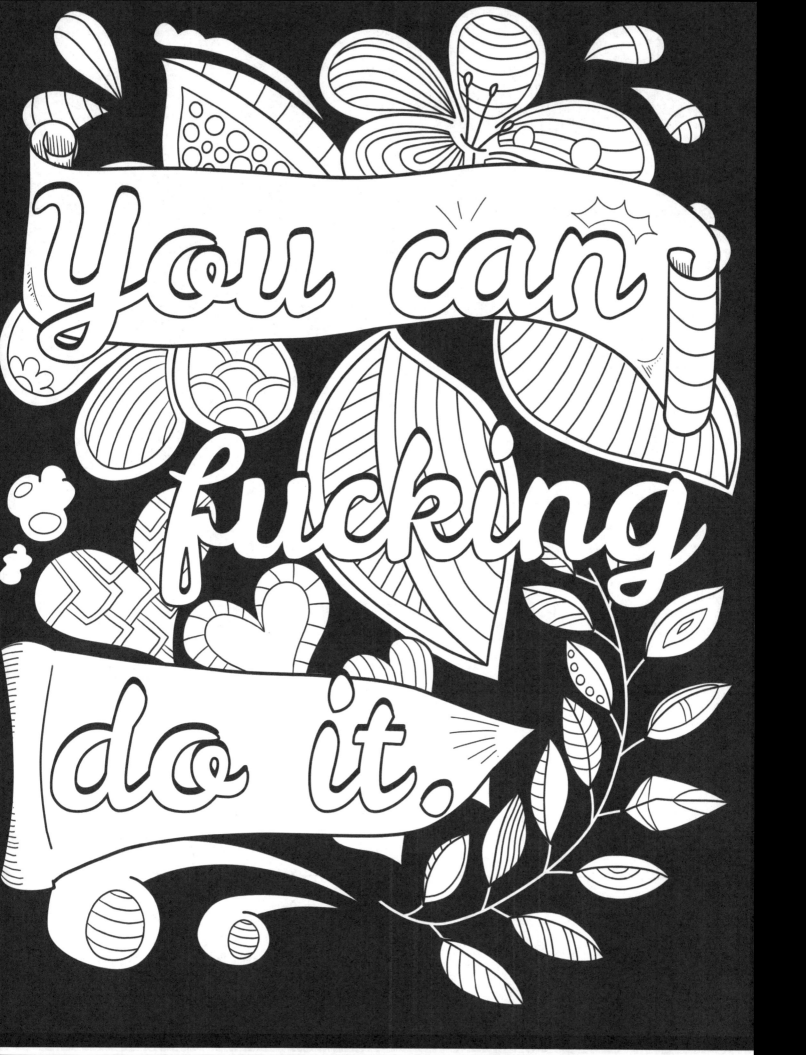

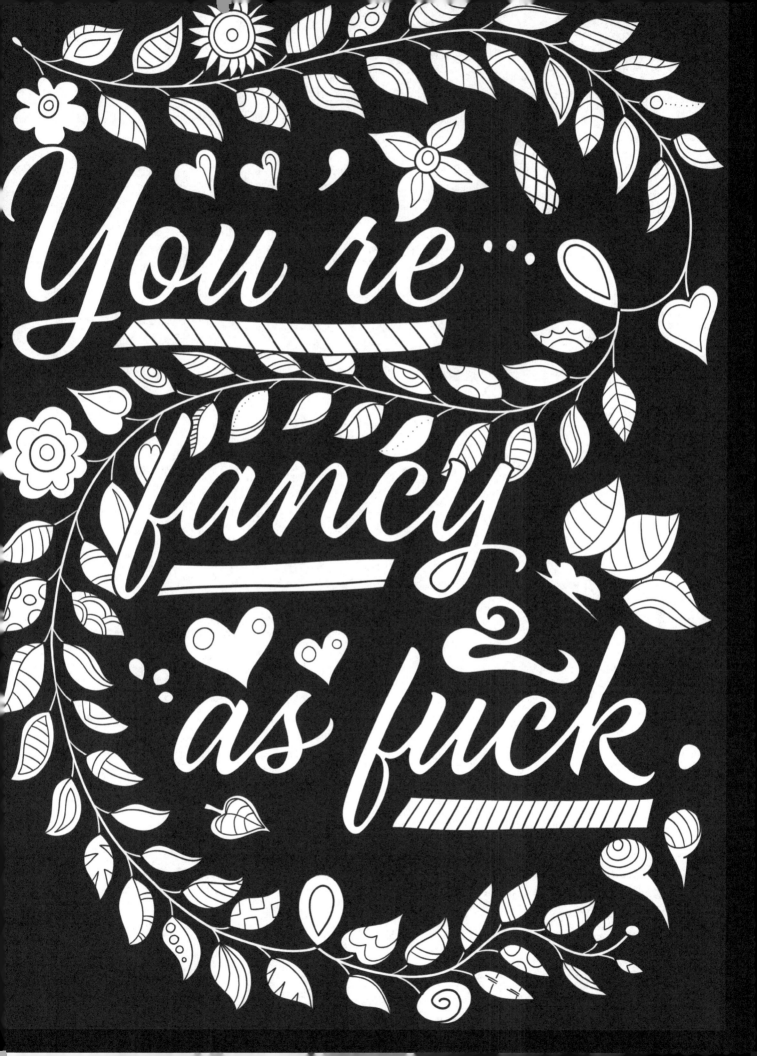

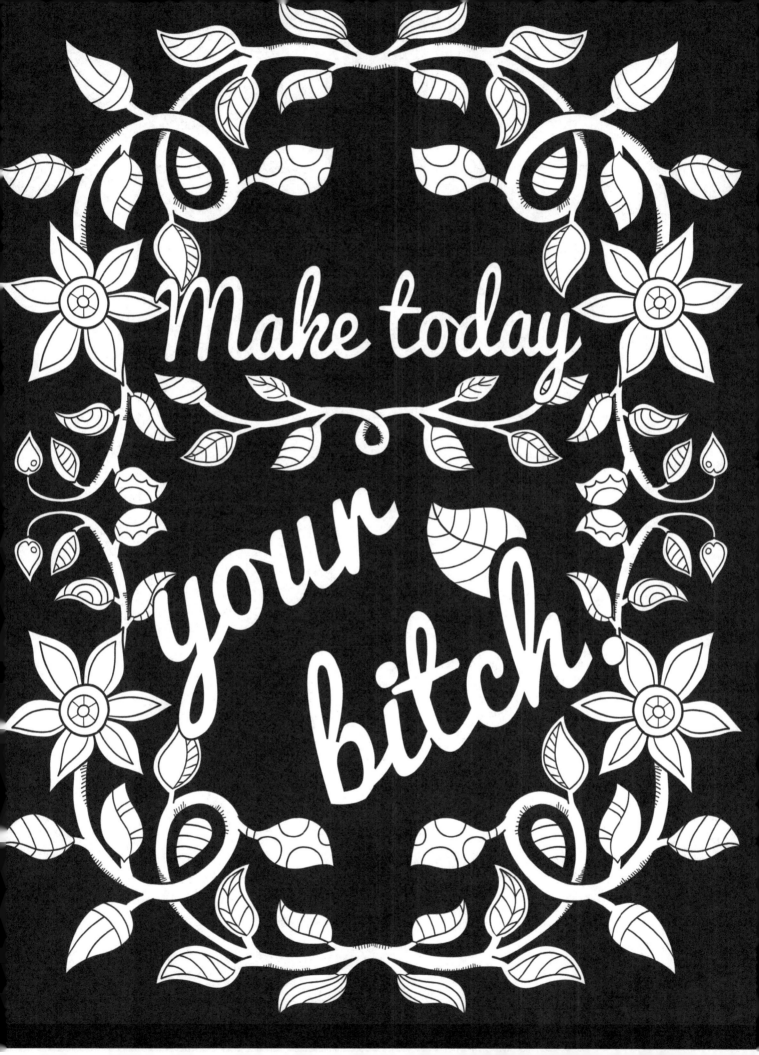

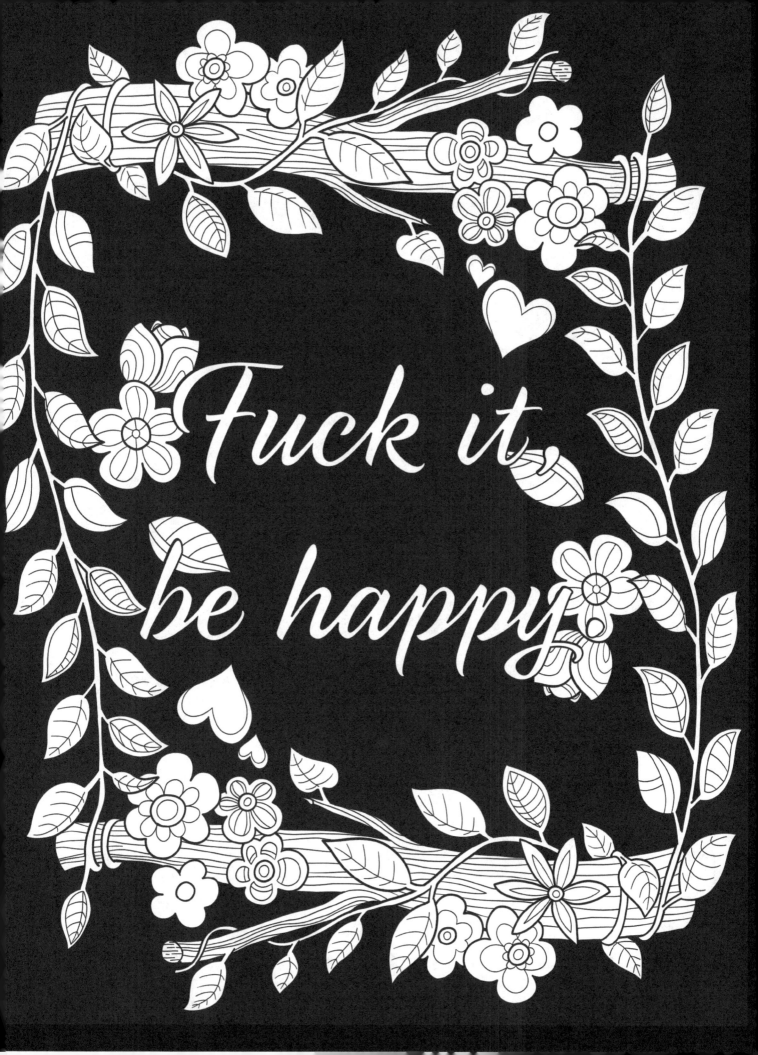

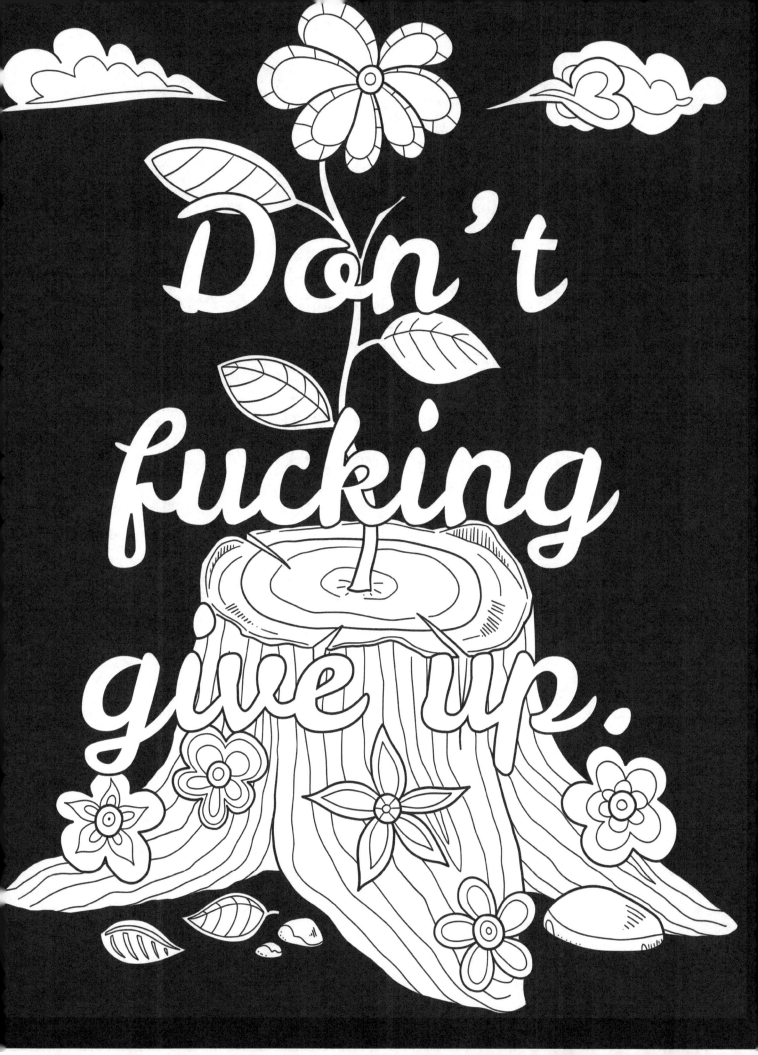

Big

Beautiful

Bitch.

let your fucking sparkle shine, bitches!

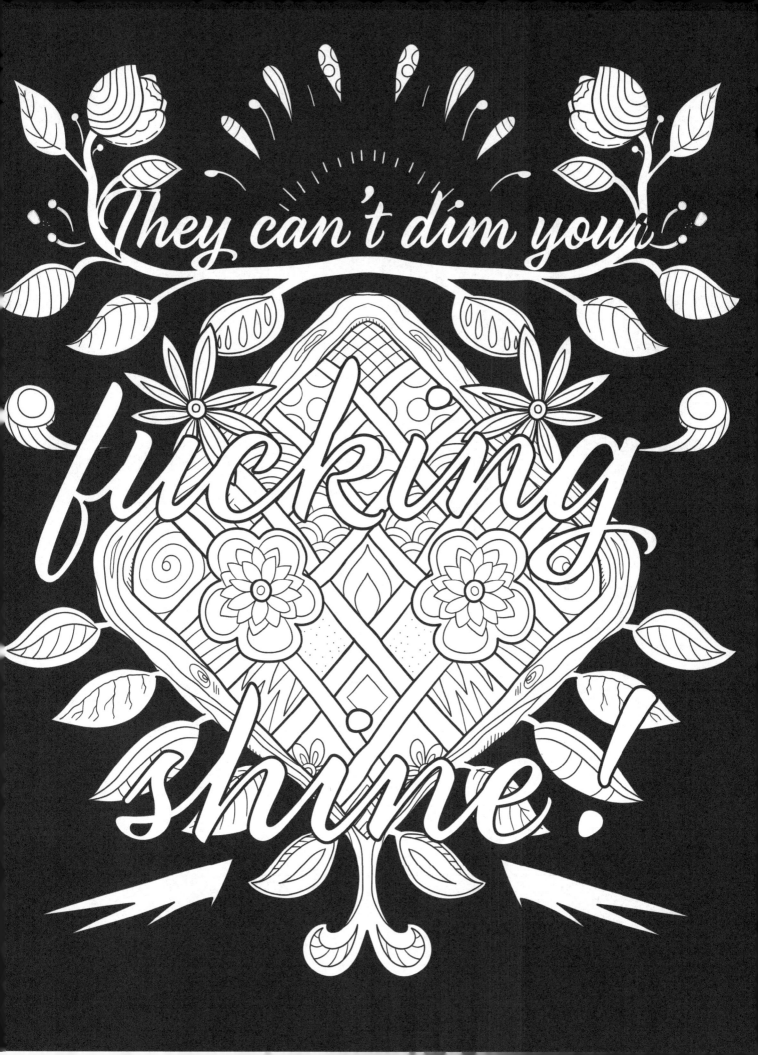

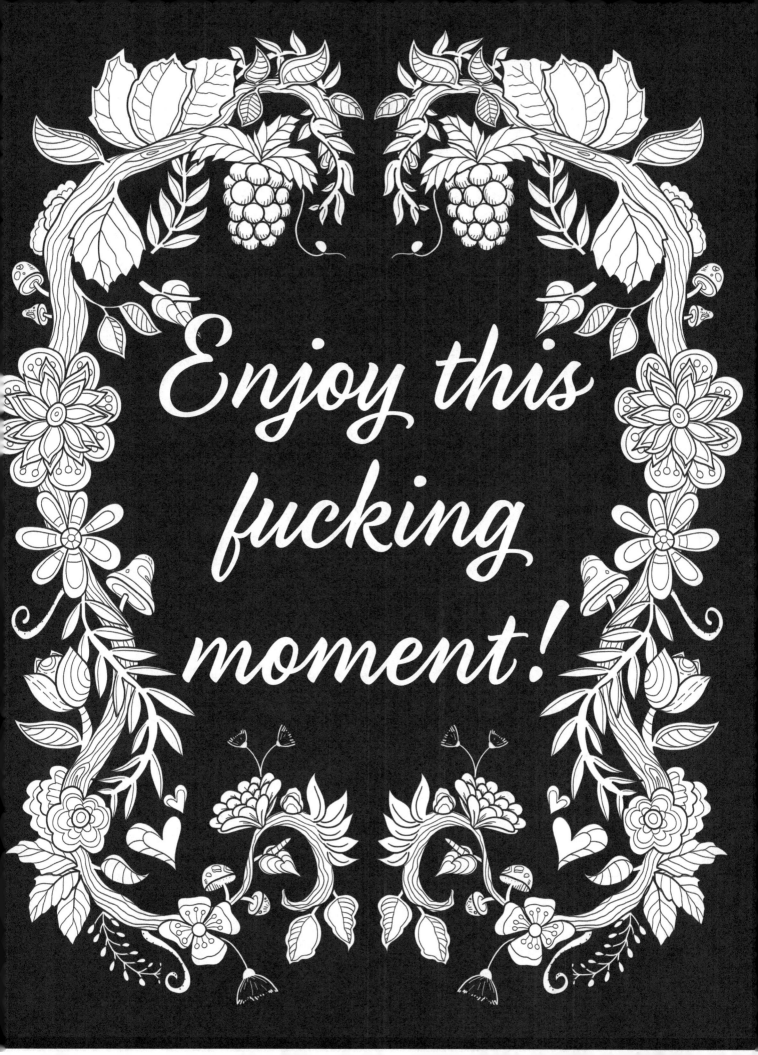

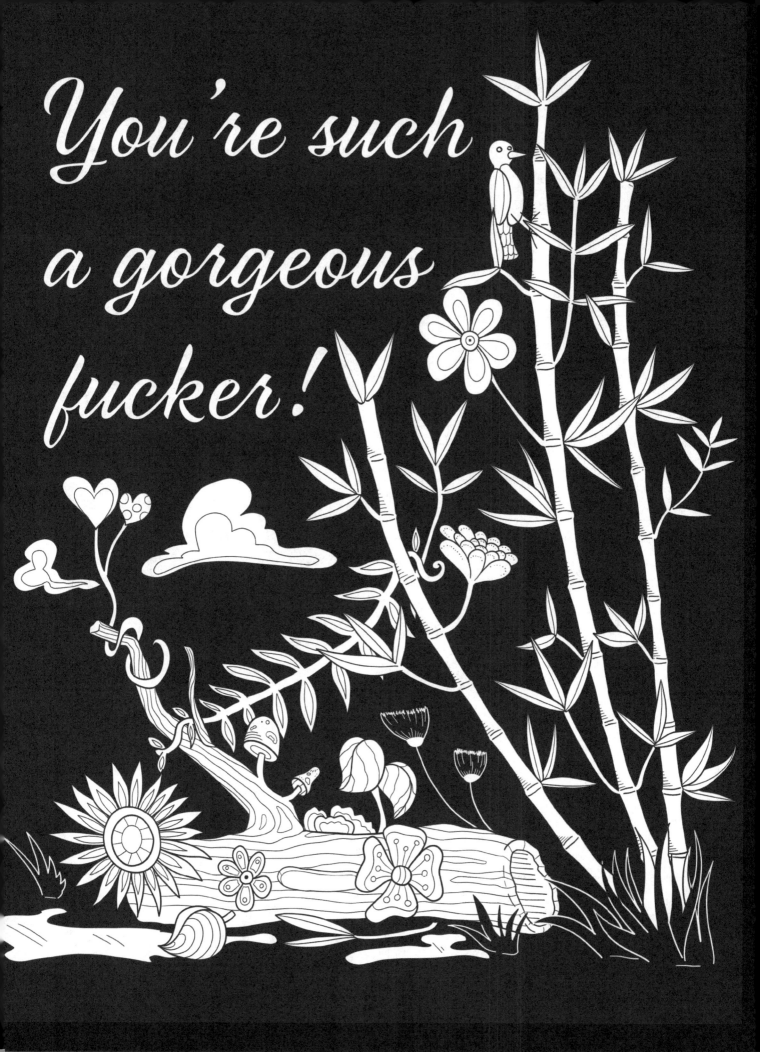

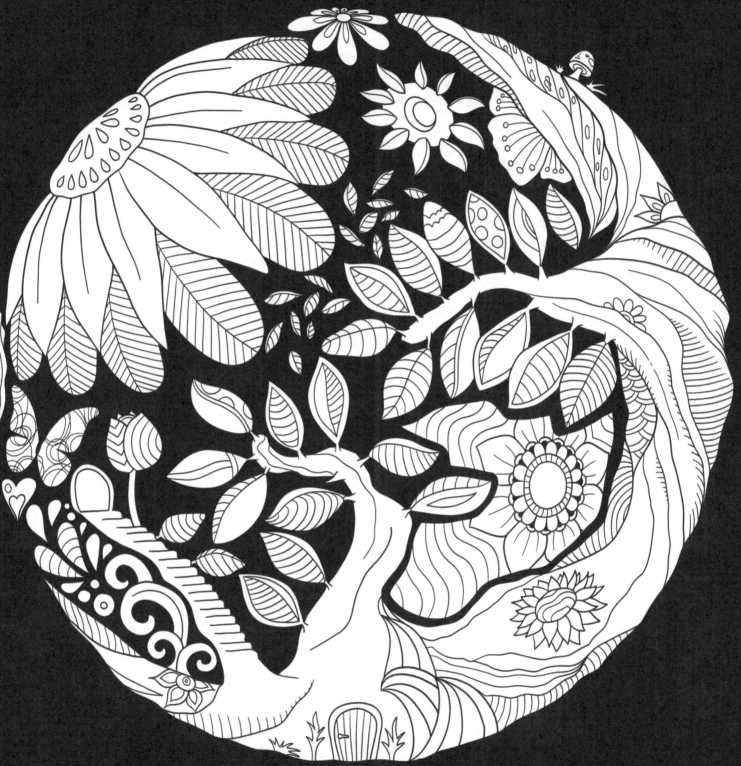

I am
the queen
bitch.

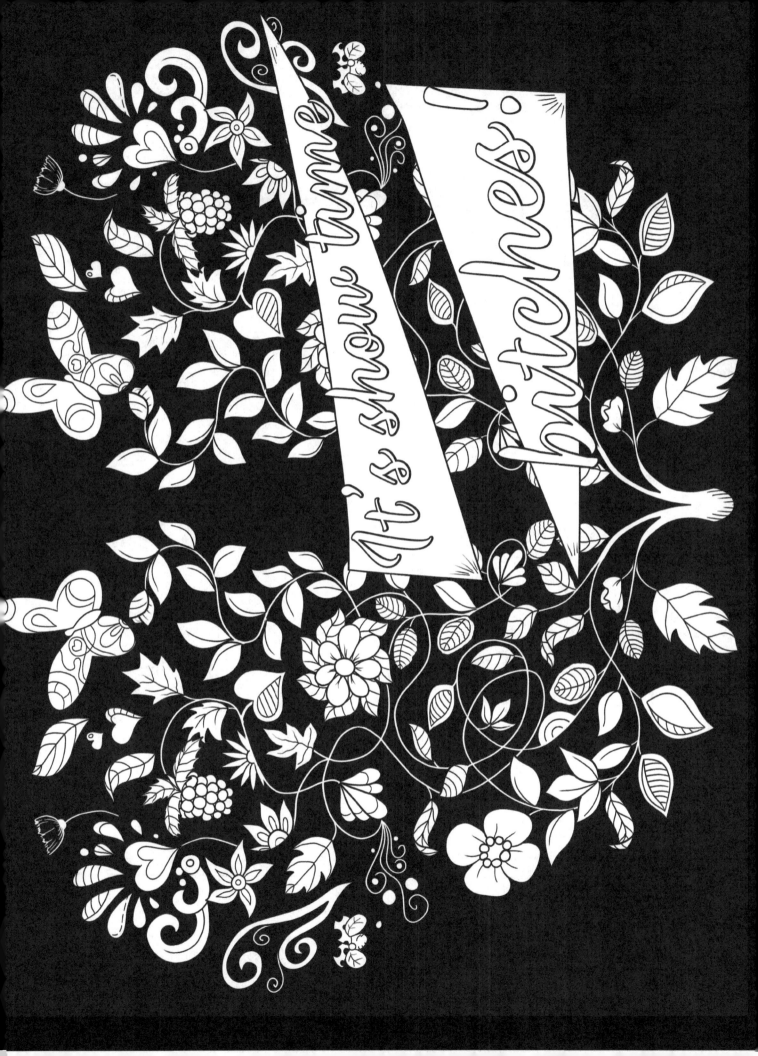

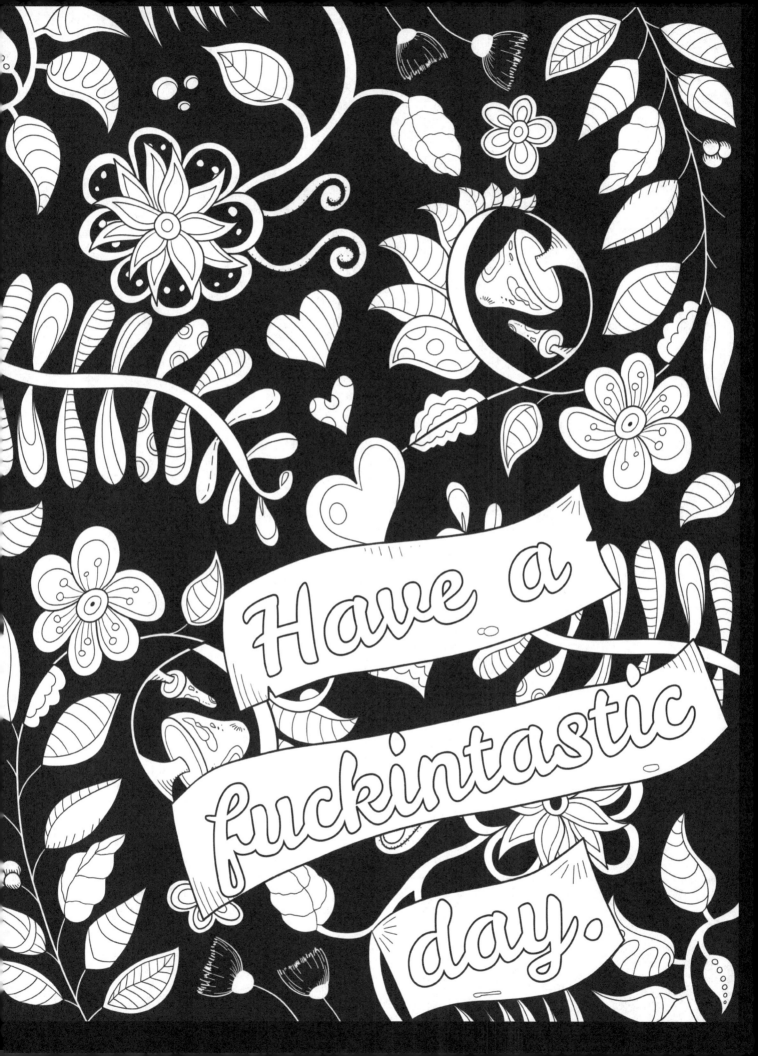

You are one stunning...

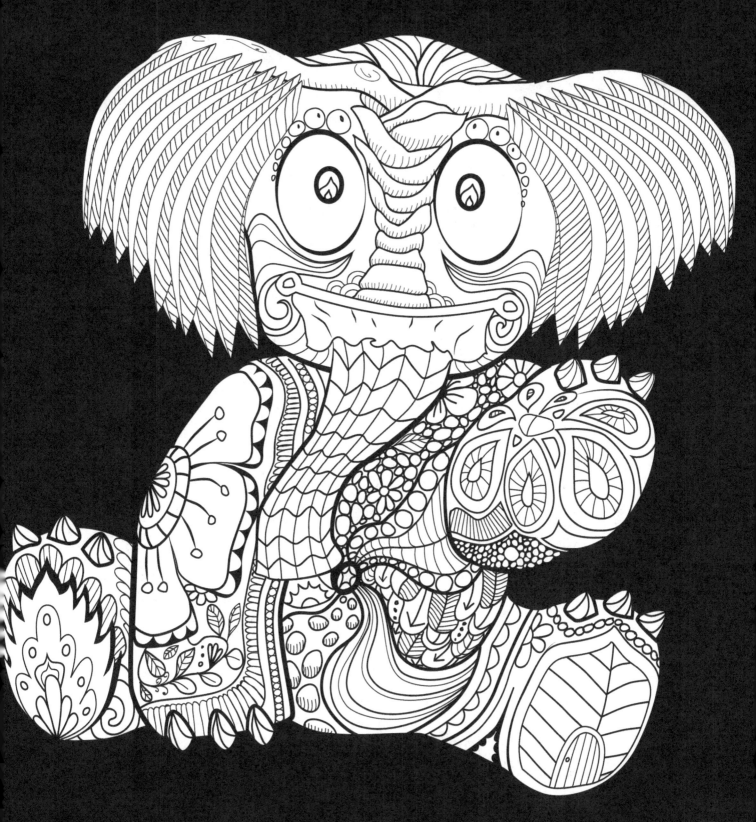

...Motherfucker!

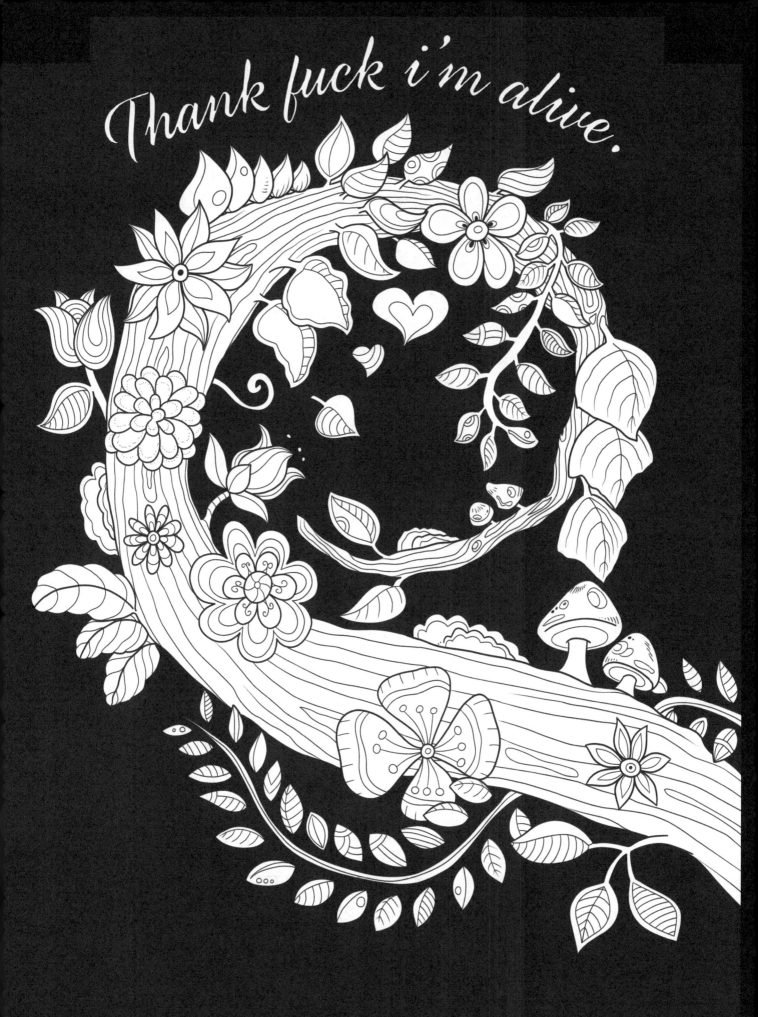

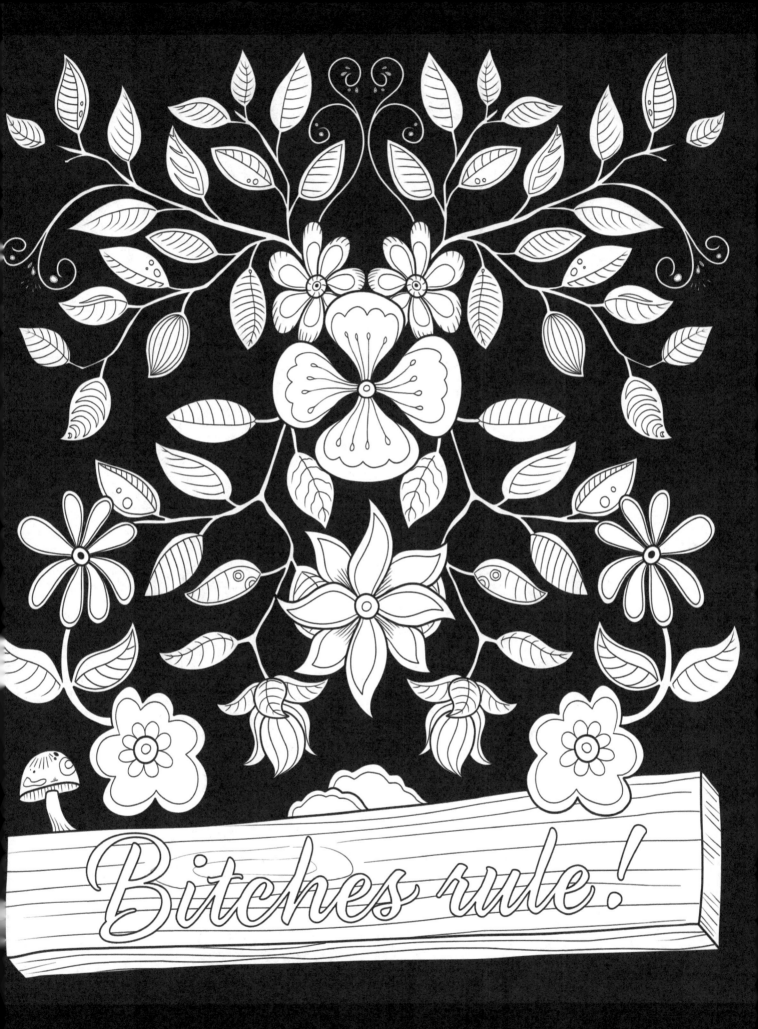

Made in United States
Troutdale, OR
02/16/2024

17729994R00031